Dream Catcher
mindfulness

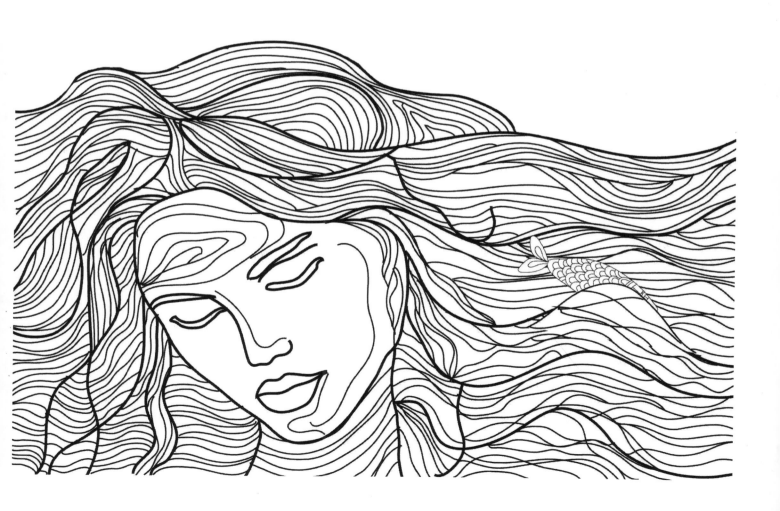

Dream Catcher: mindfulness

First published in the United Kingdom in 2015 by
Bell & Mackenzie Publishing Limited

ISBN 978-1-909855-93-9

A CIP catalogue record of this book is available from the British Library

Created by Christina Rose
Contributors: Letitia Clouden

www.bellmackenzie.com

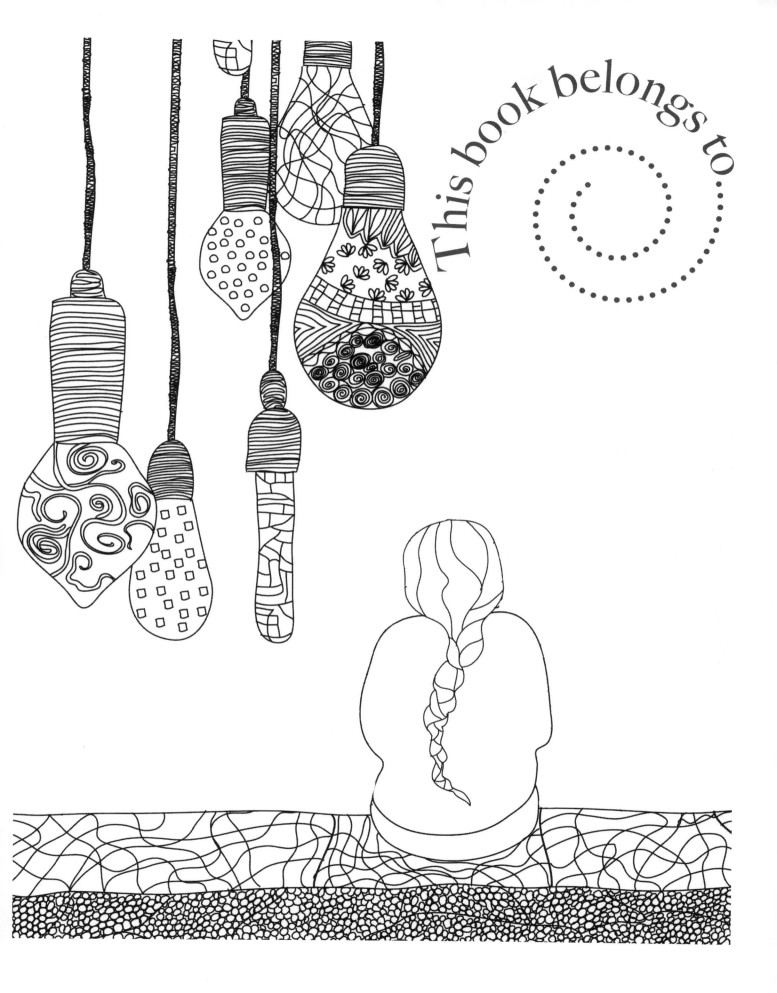

This book belongs to…………

In the end, just three things matter: How well we have lived. How well we have loved. How well we have learned to let go.

Jack Kornfield

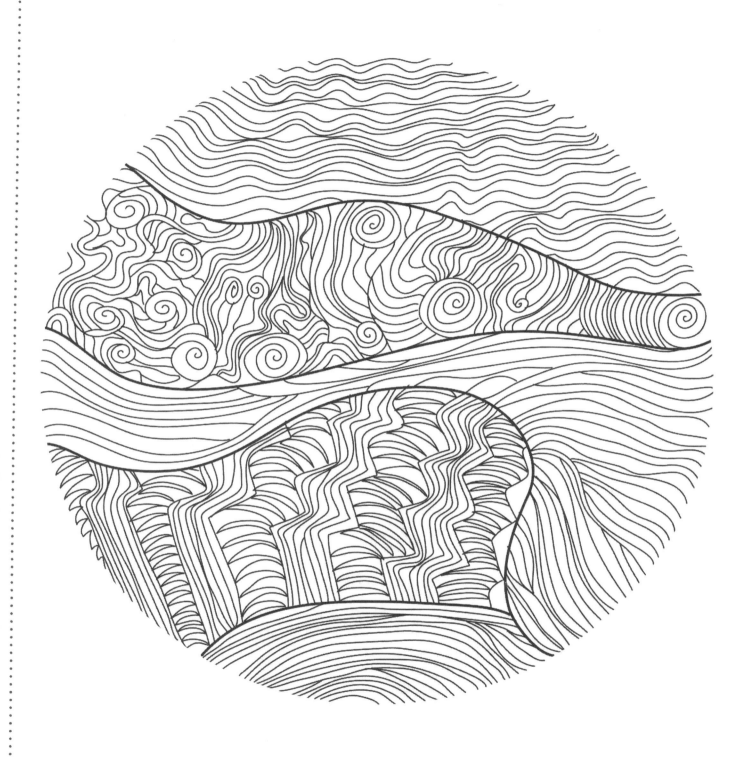

Feelings come and go like clouds in a windy sky. Conscious breathing is my anchor.

Thích Nhất Hạnh

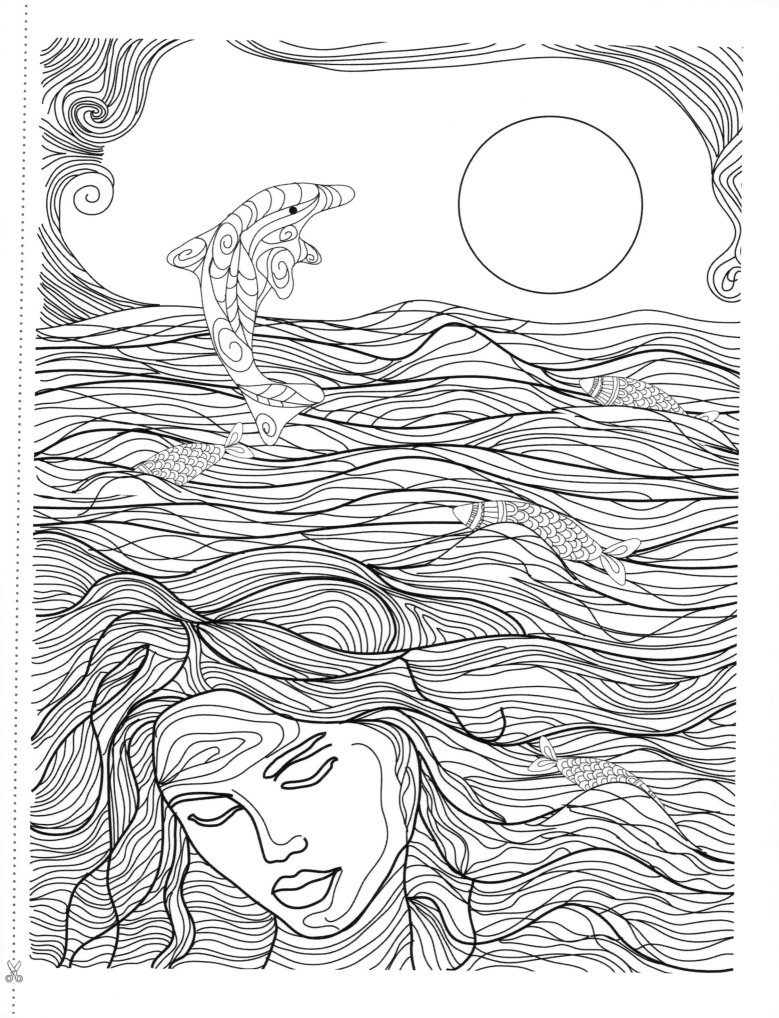

The most fundamental aggression to ourselves, the most fundamental harm we can do to ourselves, is to remain ignorant by not having the courage and the respect to look at ourselves honestly and gently.

Pema Chödrön

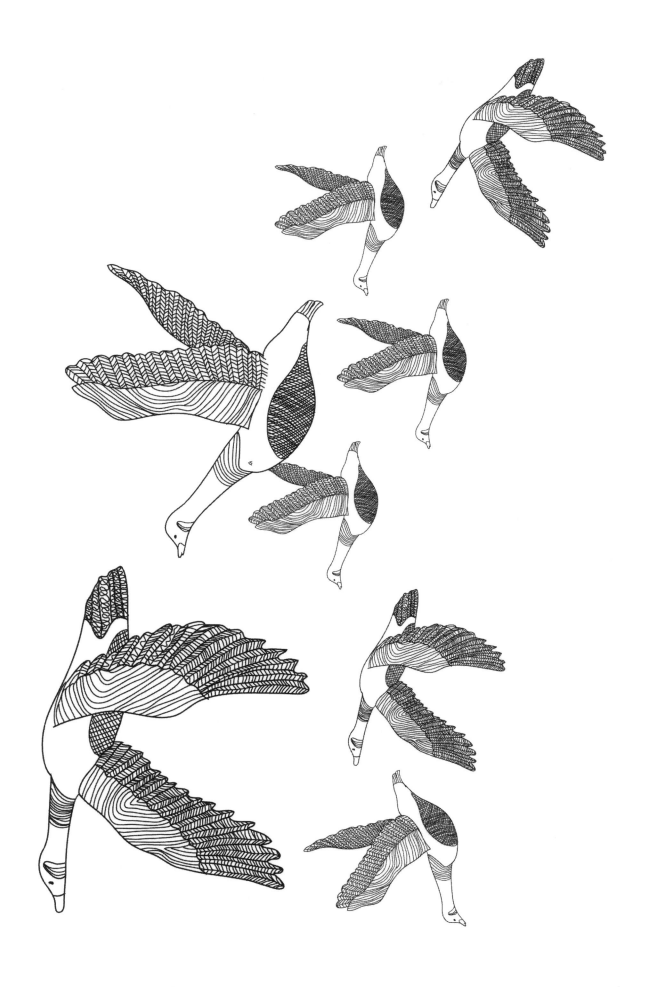

Stay present for the "now" of your life. It's your "point of power."

Doug Dillon

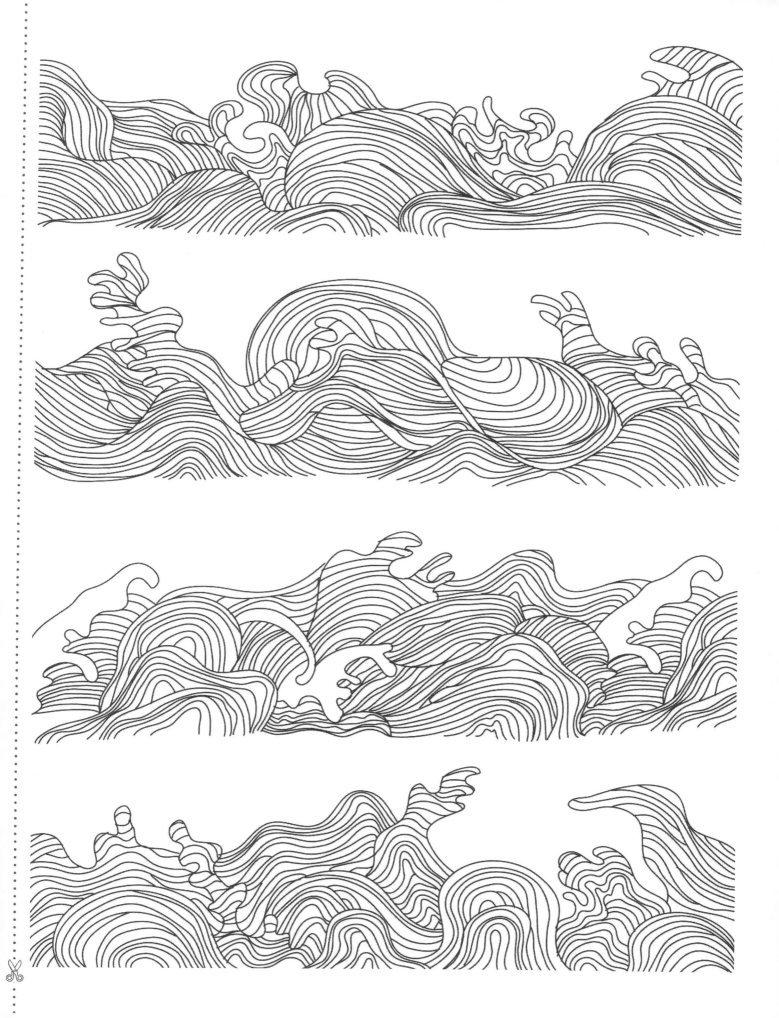

If you want to conquer the anxiety of life, live in the moment, live in the breath.

Amit Ray

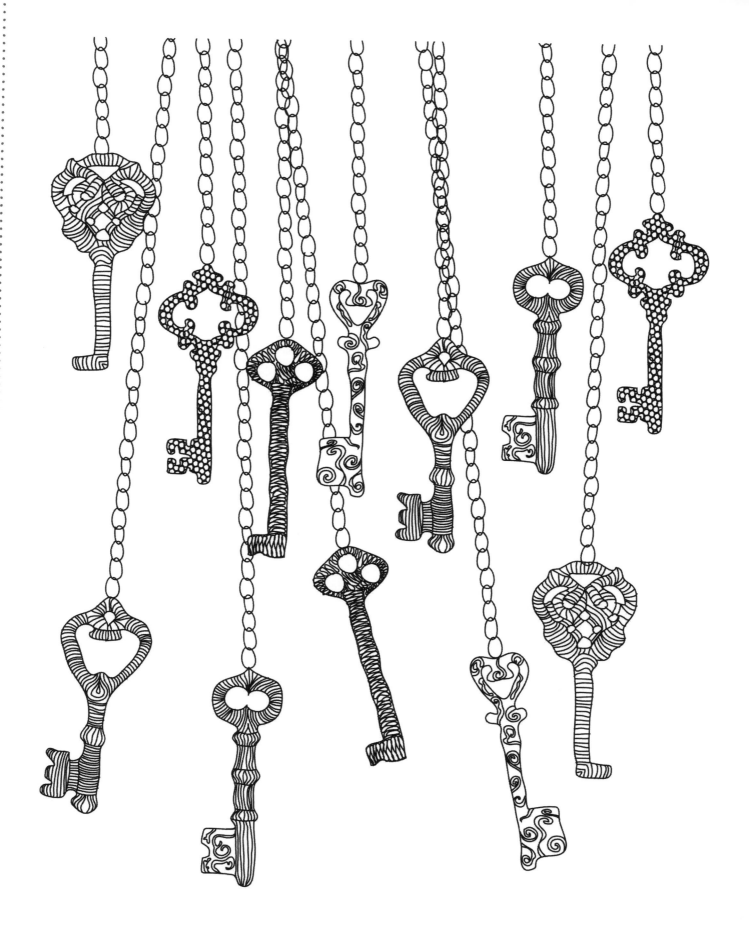

The present moment is filled with joy and happiness. If you are attentive, you will see it.

Thích Nhất Hạnh

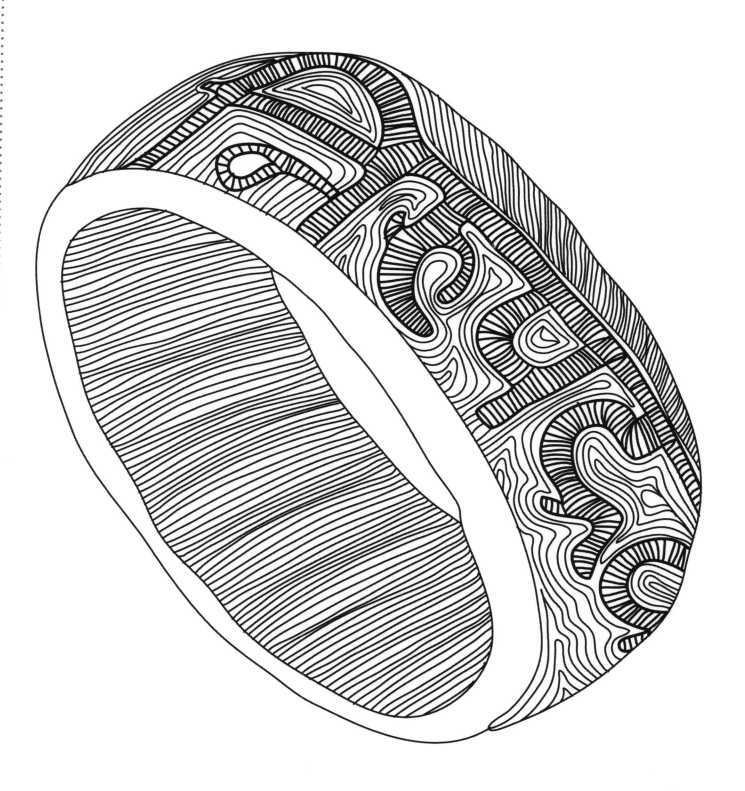

If someone comes along and shoots an arrow into your heart, it's fruitless to stand there and yell at the person. It would be much better to turn your attention to the fact that there's an arrow in your heart...

Pema Chödrön

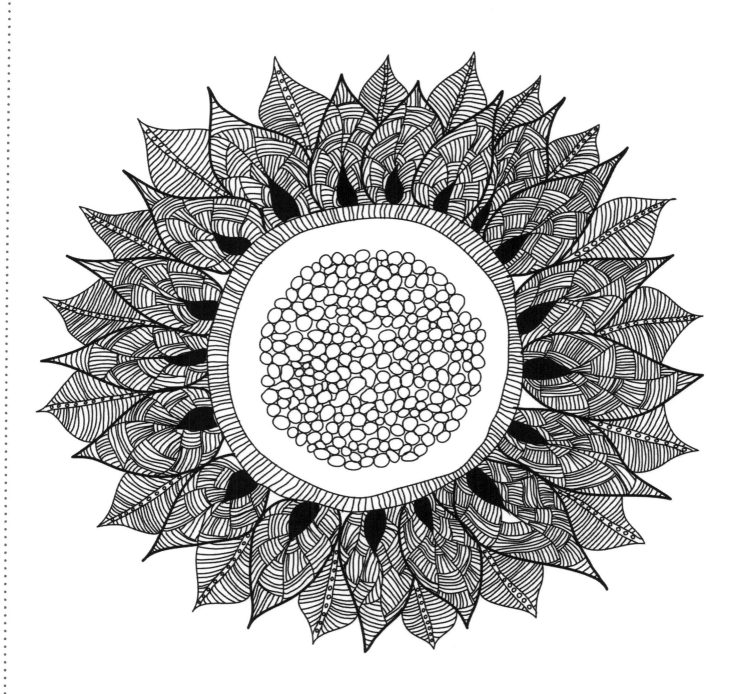
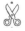

Looking at beauty in the world, is the first step of purifying the mind.

Amit Ray

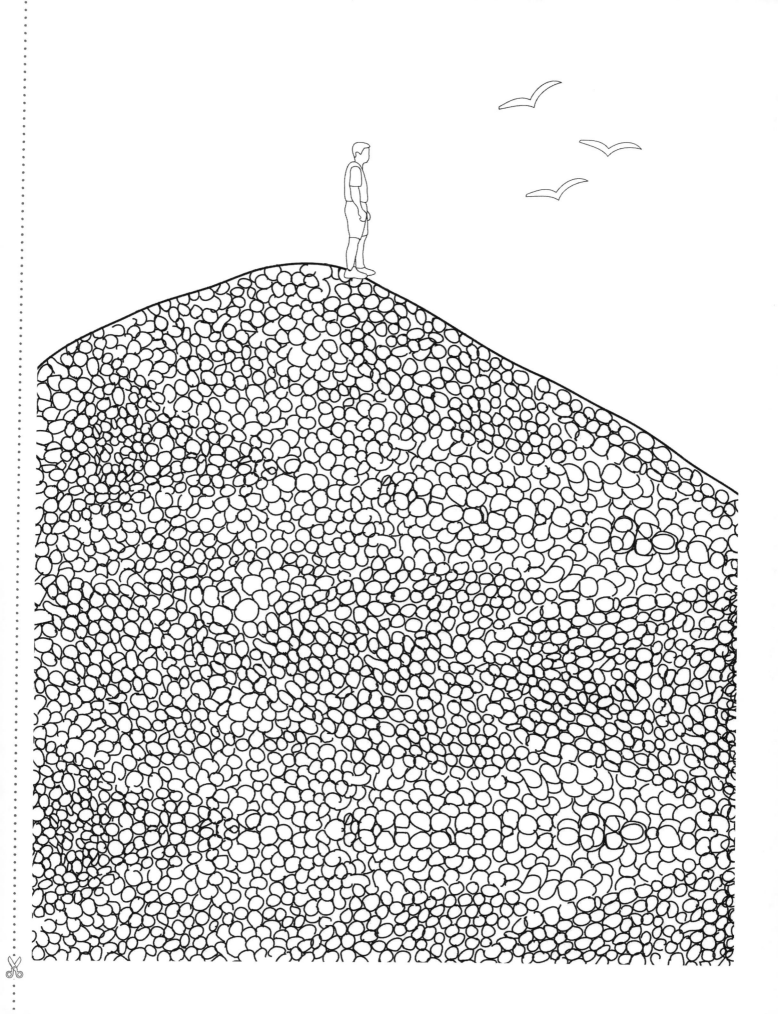

Everything is created twice, first in the mind and then in reality.

Robin S. Sharma

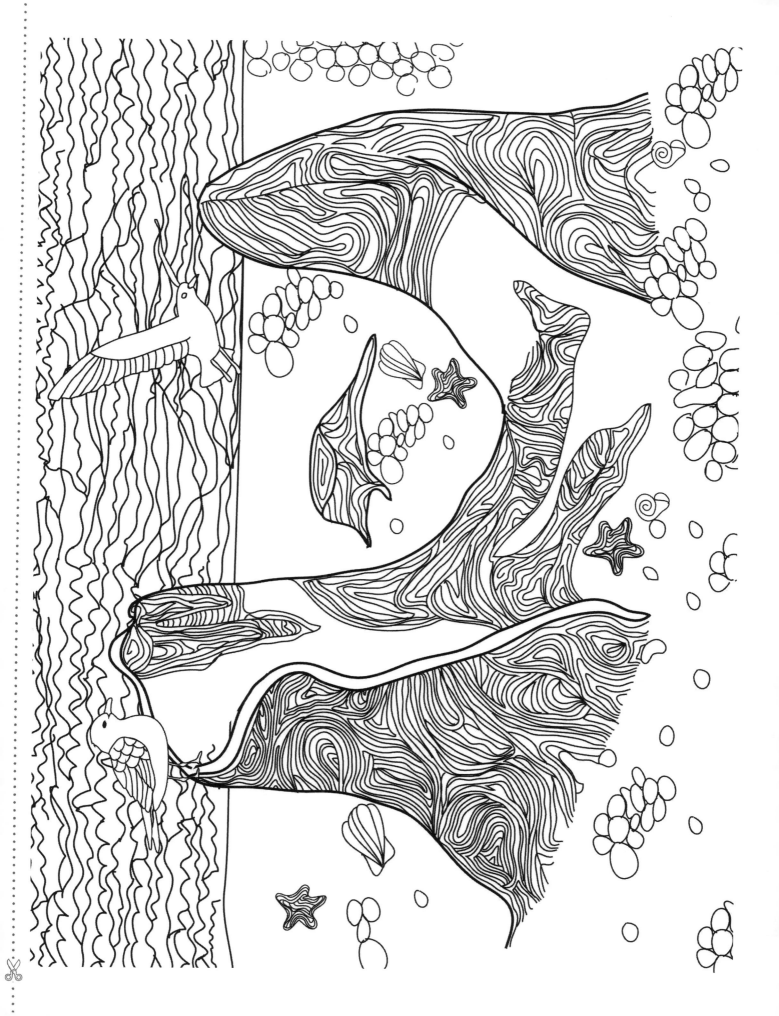

Do not ruin today with mourning tomorrow.

Catherynne M. Valente

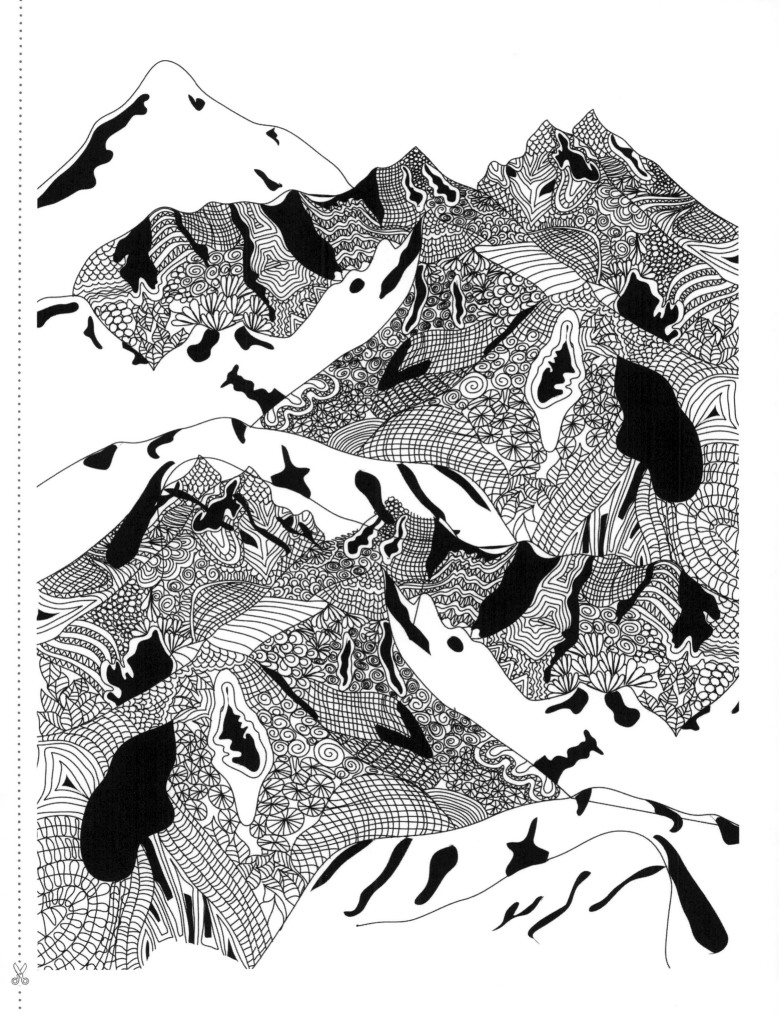

Do every act of your life as though it were the very last act of your life.

Marcus Aurelius

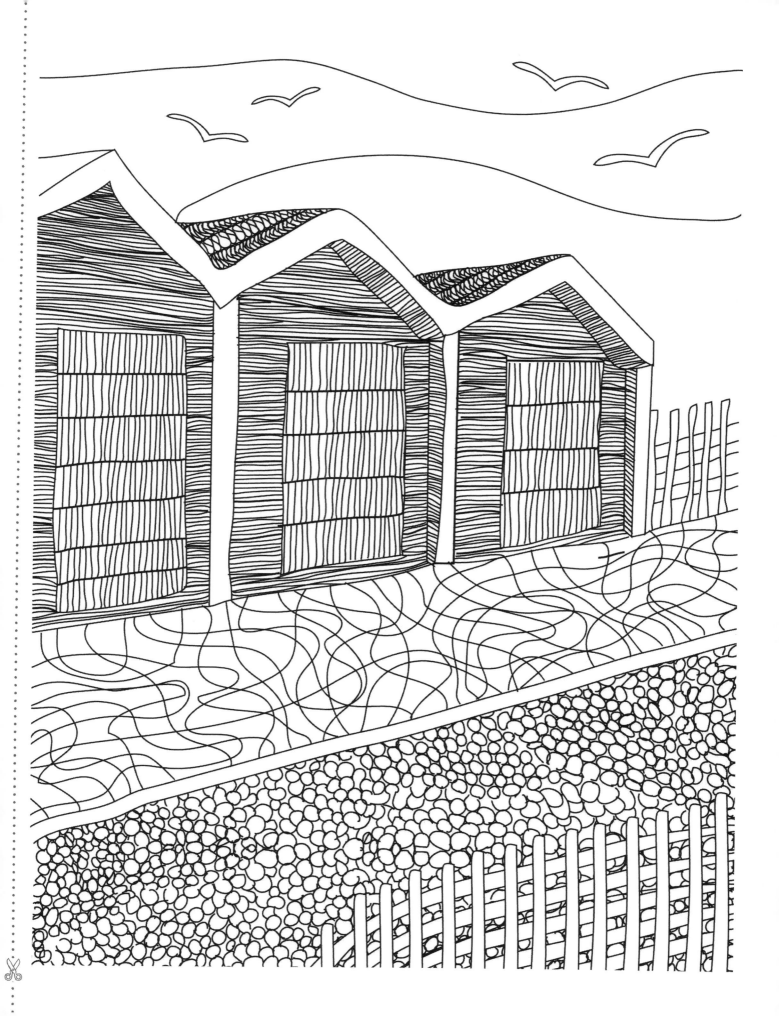

Mindfulness has never met a cognition it didn't like.

Daniel J. Siegel

Few of us ever live in the present. We are forever anticipating what is to come or remembering what has gone.

Louis L'Amour

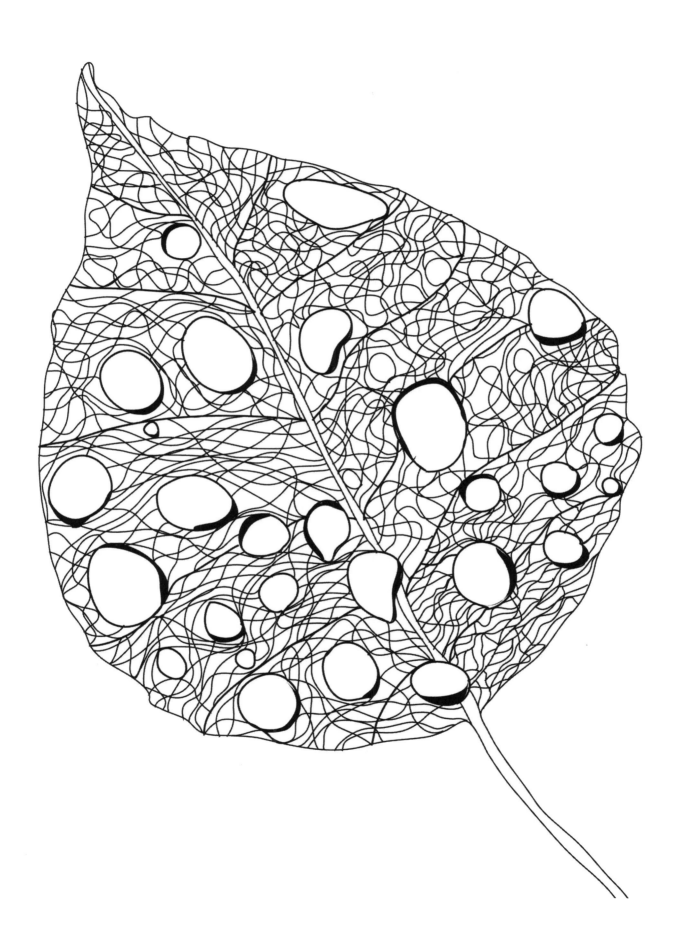

Be happy in the moment, that's enough. Each moment is all we need, not more.

Mother Teresa

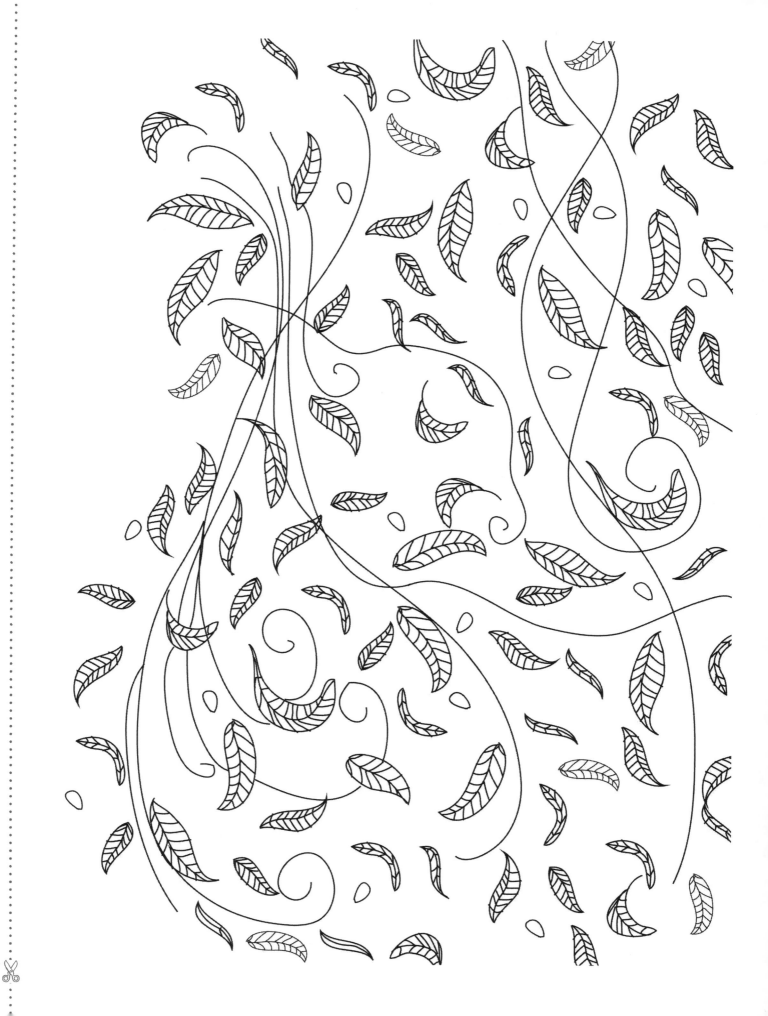

Our duty is wakefulness, the fundamental condition of life itself. The unseen, the unheard, the untouchable is what weaves the fabric of our see-able universe together.

Robin Craig Clark

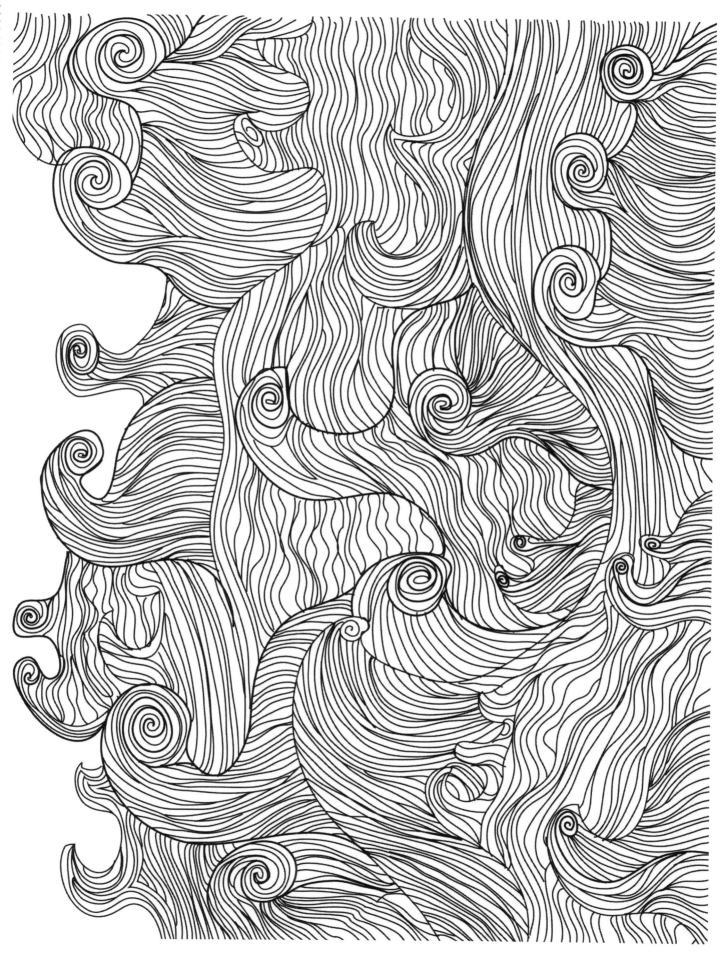
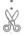

I am grateful for all those dark years, even though in retrospect they seem like a long, bitter prayer that was answered finally.

Marilynne Robinson

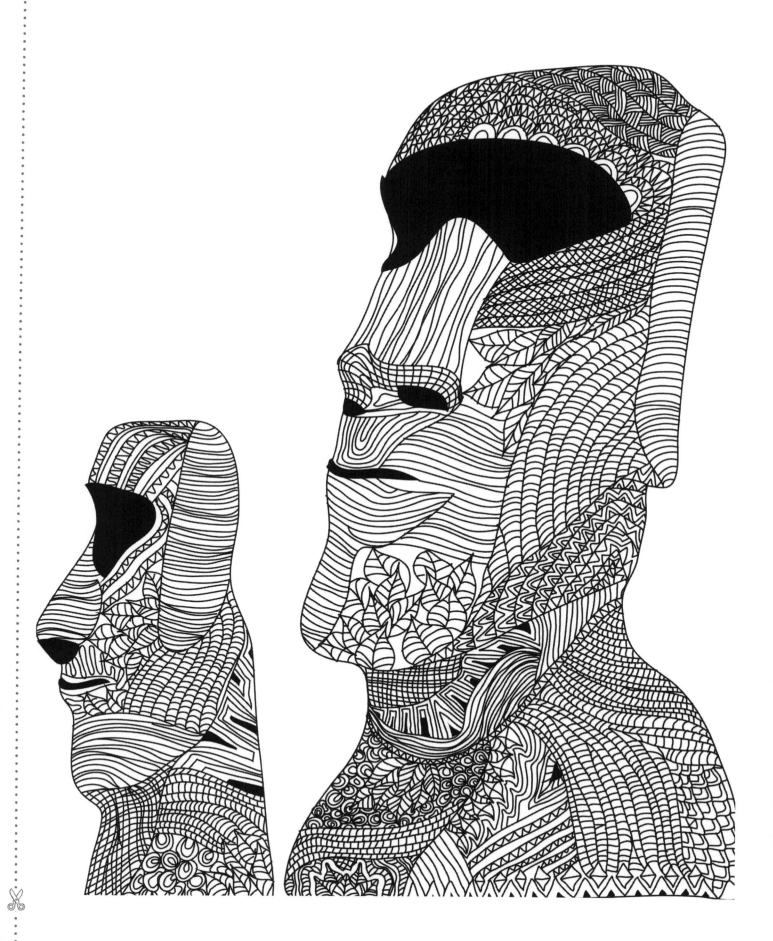

Perfection of character is this: to live each day as if it were your last, without frenzy, without apathy, without pretence.

Marcus Aurelius

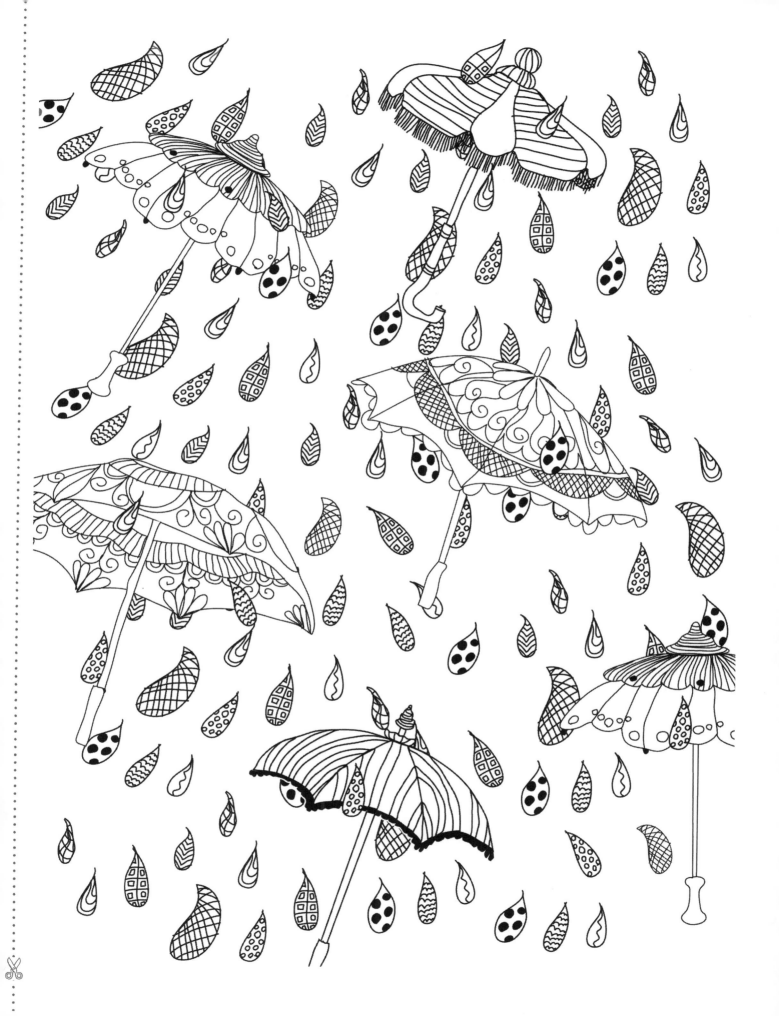

In this moment, there is plenty of time. In this moment, you are precisely as you should be. In this moment, there is infinite possibility.

Victoria Moran

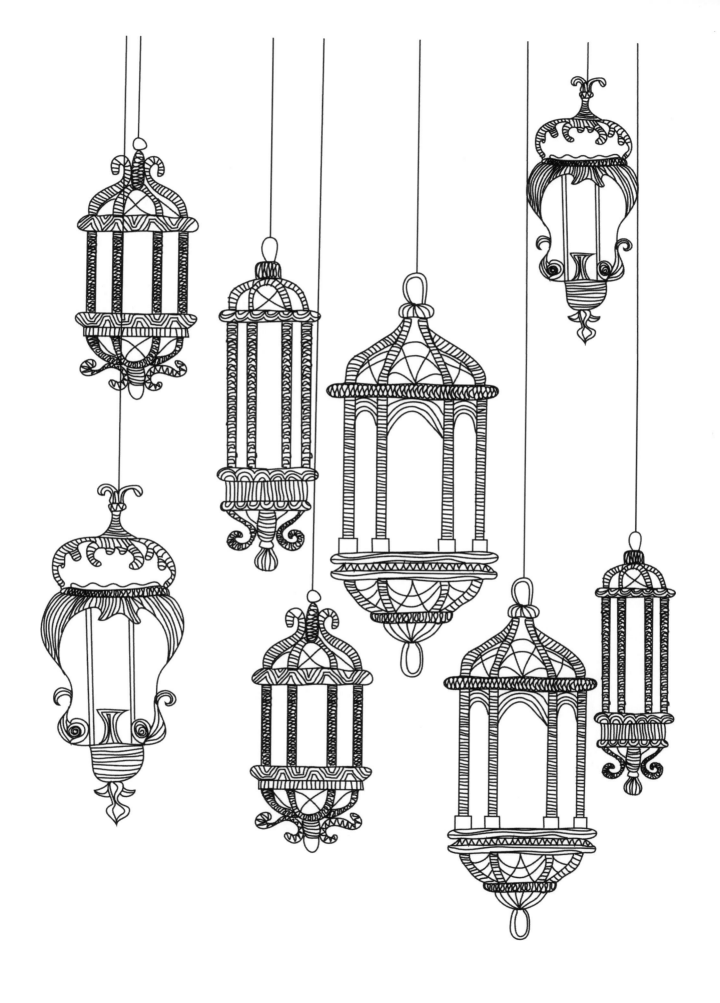

There are a thousand thousand reasons to live this life, everyone of them sufficient.

Marilynne Robinson

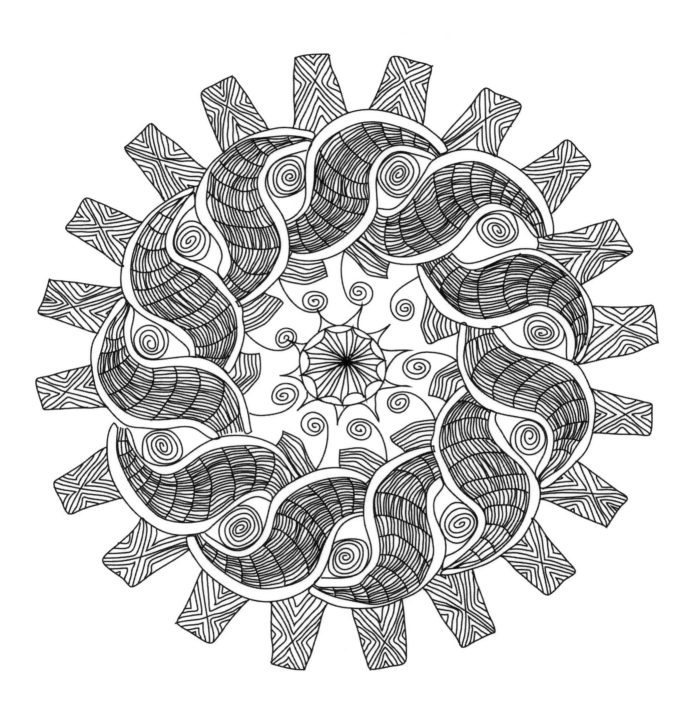

Observation of the moment-to-moment experience cleanses the mental layers, one after another.

Amit Ray

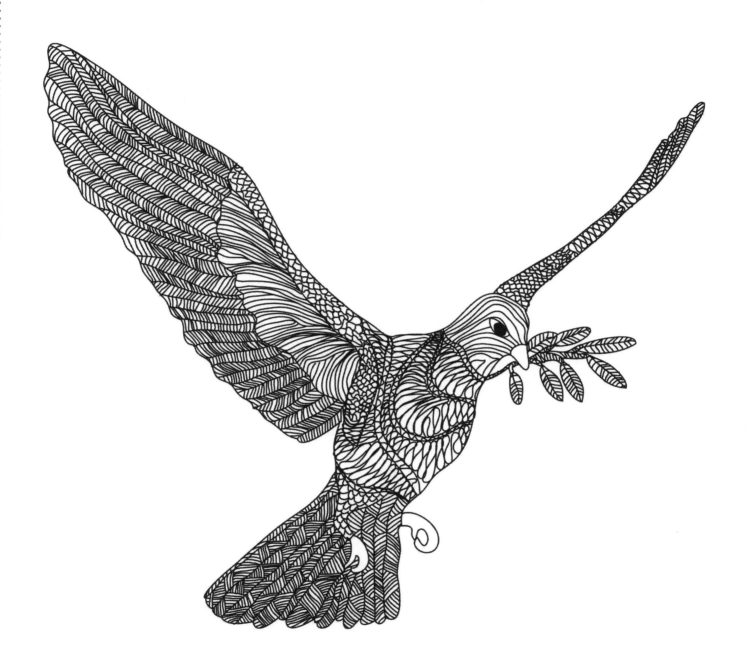
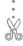

Restore your attention or bring it to a new level by dramatically slowing down whatever you're doing.

Sharon Salzberg

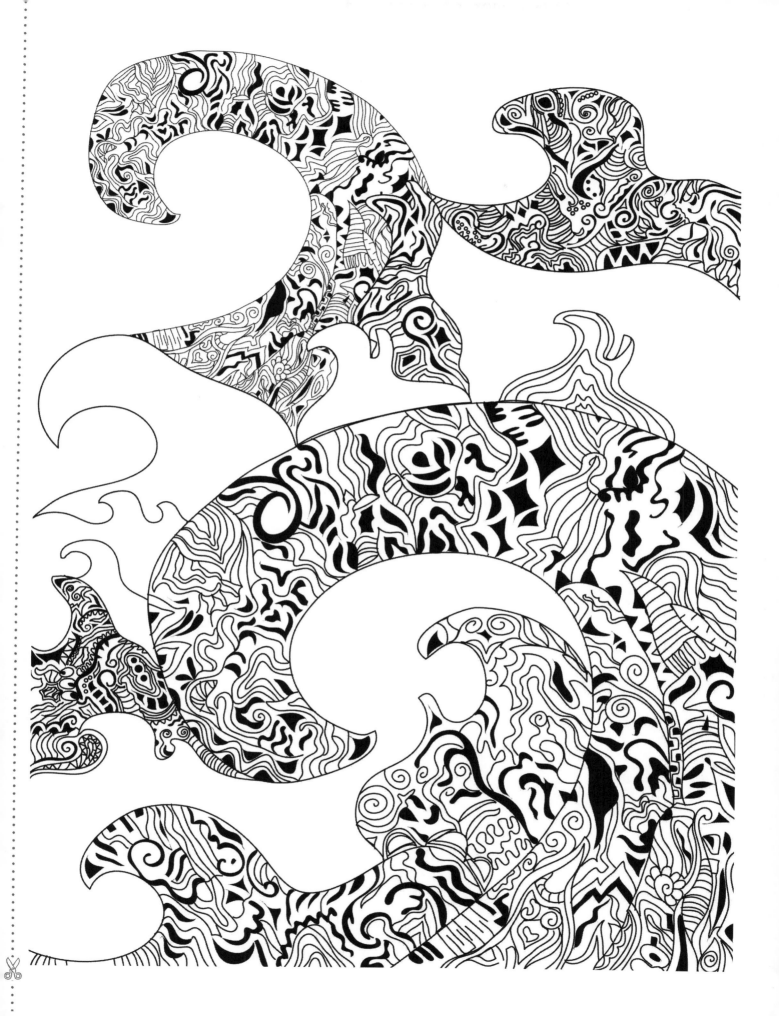

Breath is the finest gift of nature. Be grateful for this wonderful gift.

Amit Ray

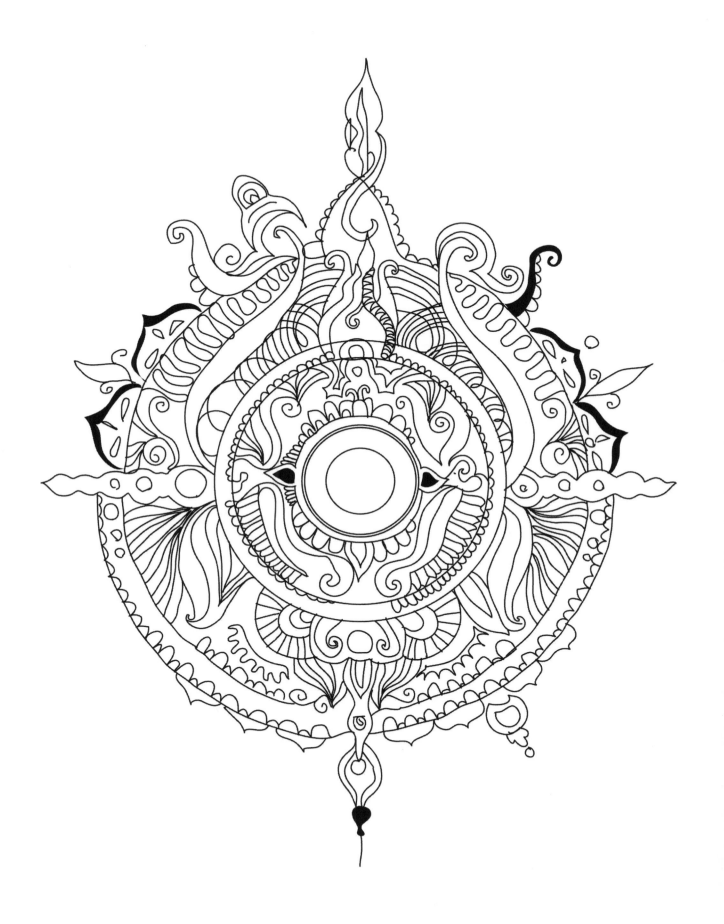

I don't need anyone else to distract me from myself anymore, like I always thought I would.

Charlotte Eriksson

Don't believe everything you think. Thoughts are just that - thoughts.

Allan Lokos

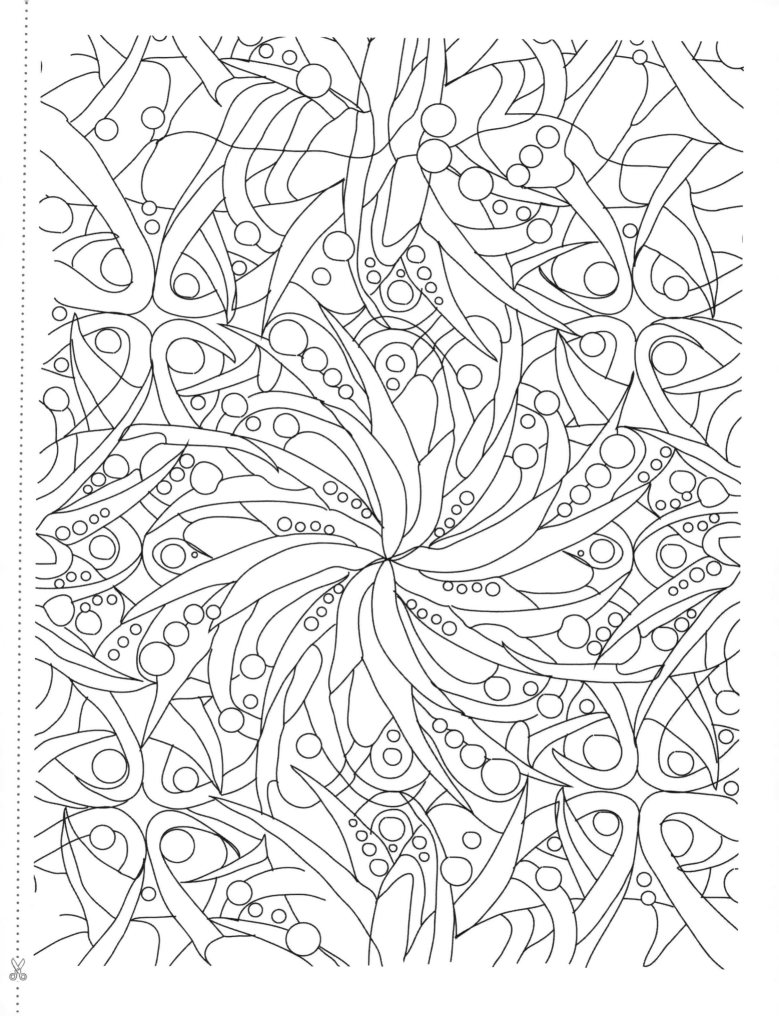

One is a great deal less anxious if one feels perfectly free to be anxious, and the same may be said of guilt.

Alan W. Watts

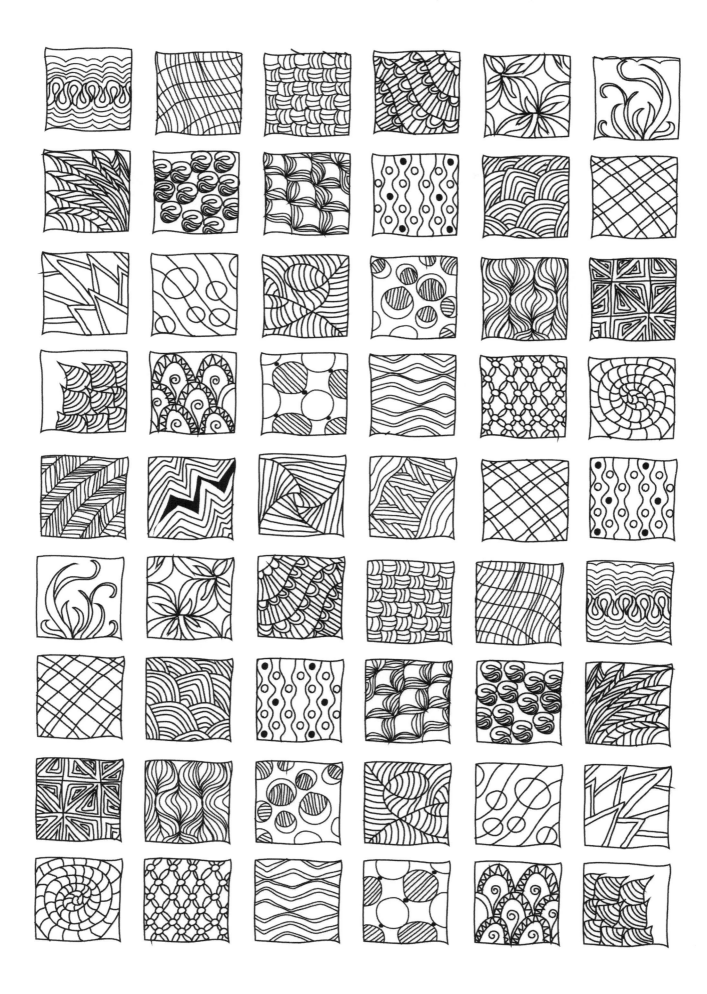

Respond; don't react. Listen; don't talk. Think; don't assume.

Raji Lukkoor

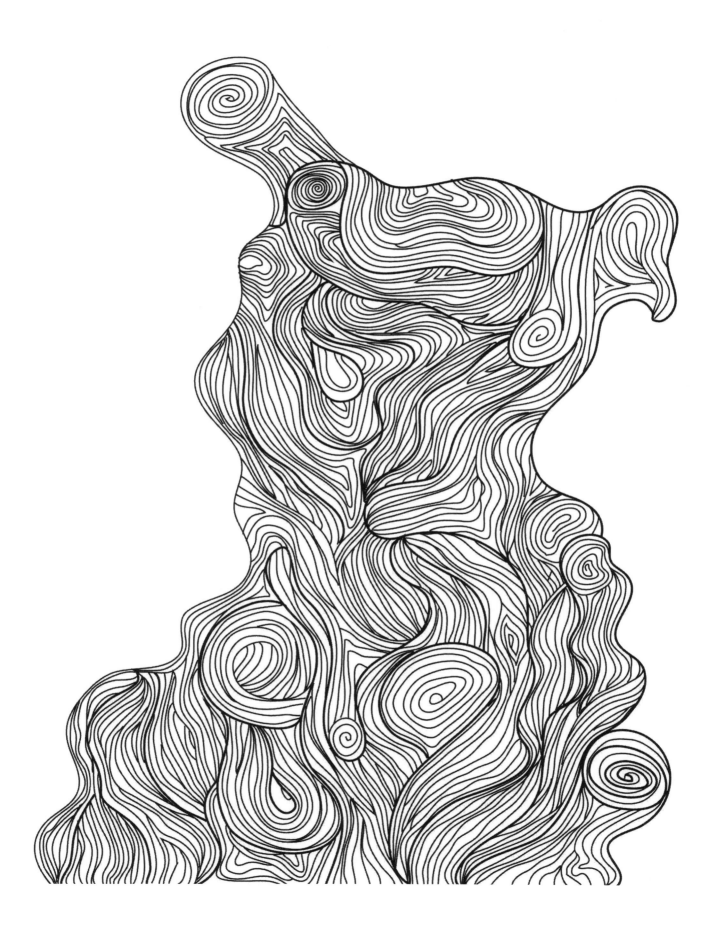

Suffering usually relates to wanting things to be different from the way they are.

Allan Lokos

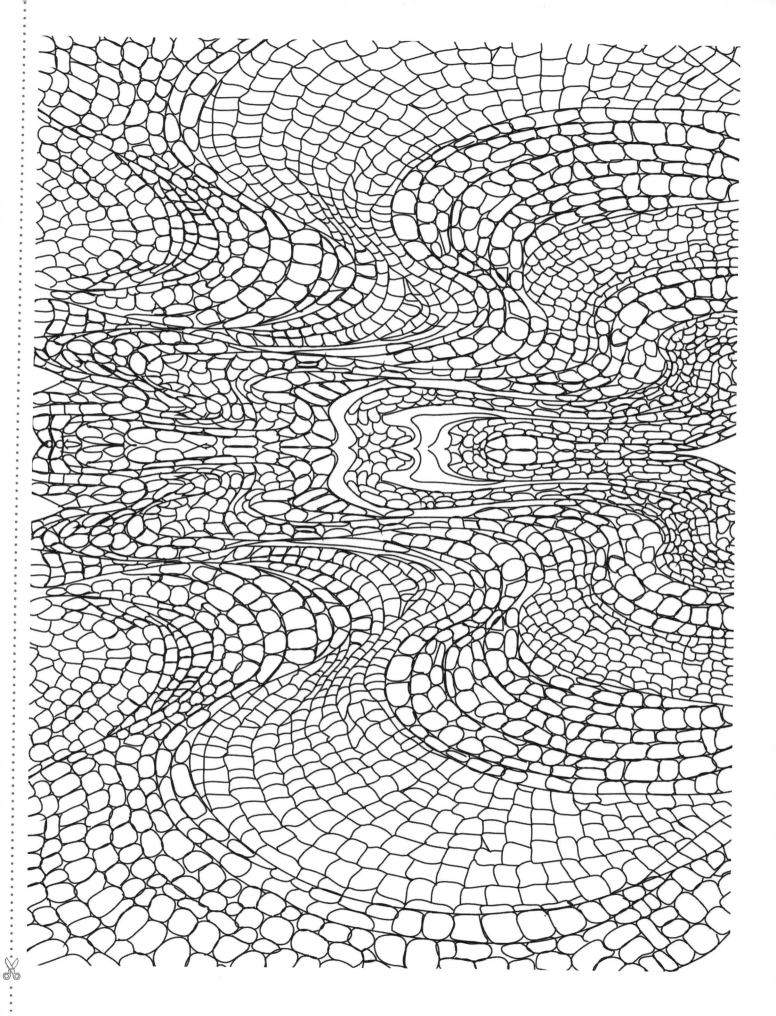

Mindfulness is simply being aware of what is happening right now without wishing it were different; enjoying the pleasant without holding on when it changes (which it will); being with the unpleasant without fearing it will always be this way (which it won't).

James Baraz

Don't let a day go by without asking who you are...each time you let a new ingredient to enter your awareness.

Deepak Chopra

Meditation is the ultimate mobile device; you can use it anywhere, anytime, unobtrusively.

Sharon Salzberg

It stands to reason that anyone who learns to live well will die well; and the same: being present in the moment, and keeping a sense of humor. The skills are the same: being present in the moment, and humble, and brave, and keeping a sense of humor.

Victoria Moran

As we encounter new experiences with a mindful and wise attention, we discover that one of three things will happen to our new experience: it will go away, it will stay the same, or it will get more intense. Whatever happens does not really matter.

Jack Kornfield

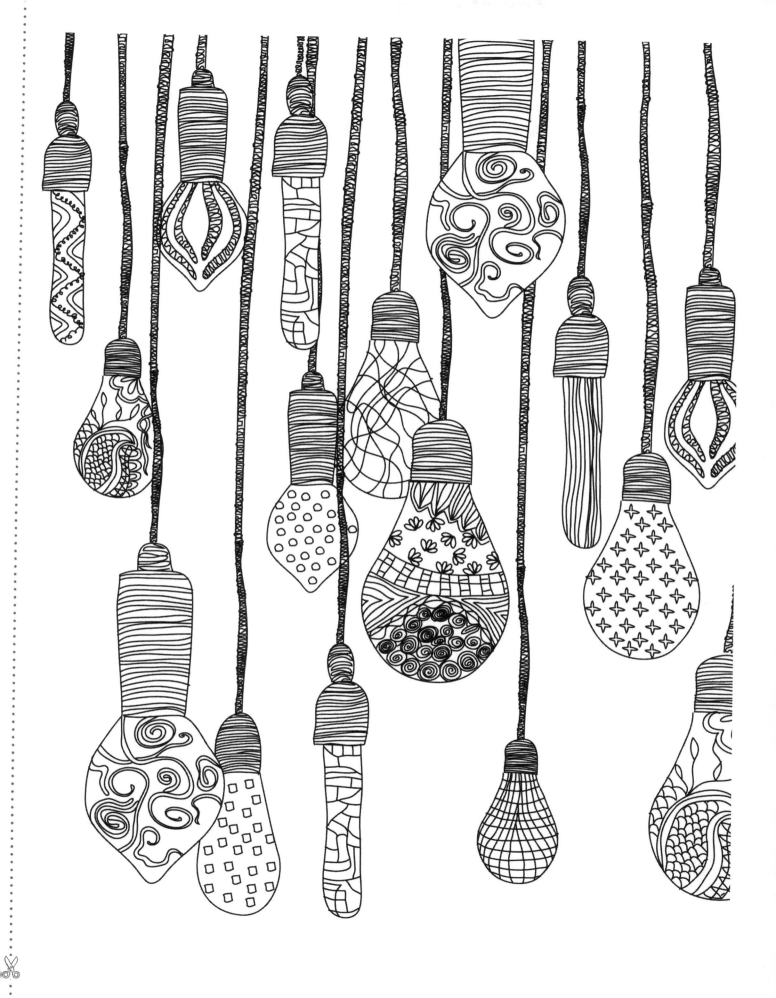

You have to remember one life, one death–this one! To enter fully the day, the hour, the moment, whether we catch it on the inbreath or outbreath, requires only a moment, this moment. And along with it all the mindfulness, and each stage of our ongoing birth, and the confident joy of our inherent luminosity. whether it appears as life or death, the moment we can muster, the confident joy of our inherent luminosity.

Stephen Levine

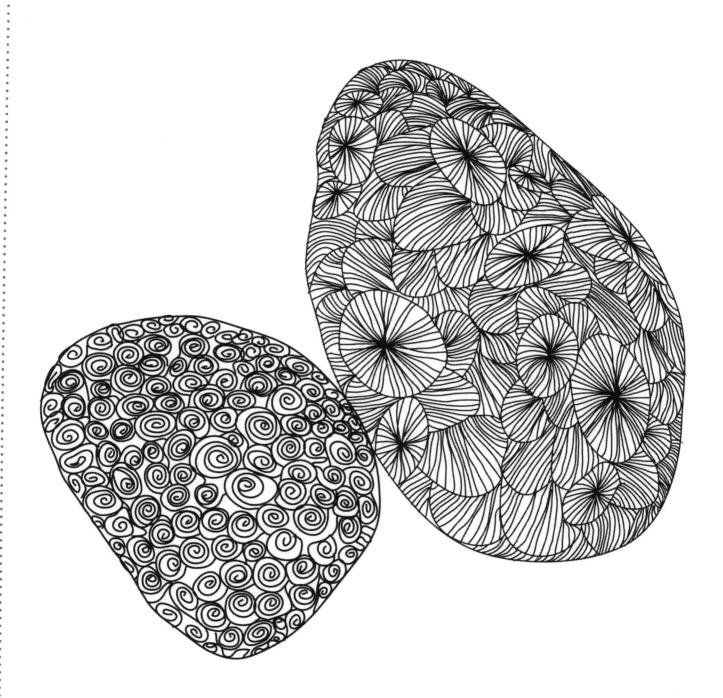

Mindfulness isn't difficult, we just need to remember to do it.

Sharon Salzberg

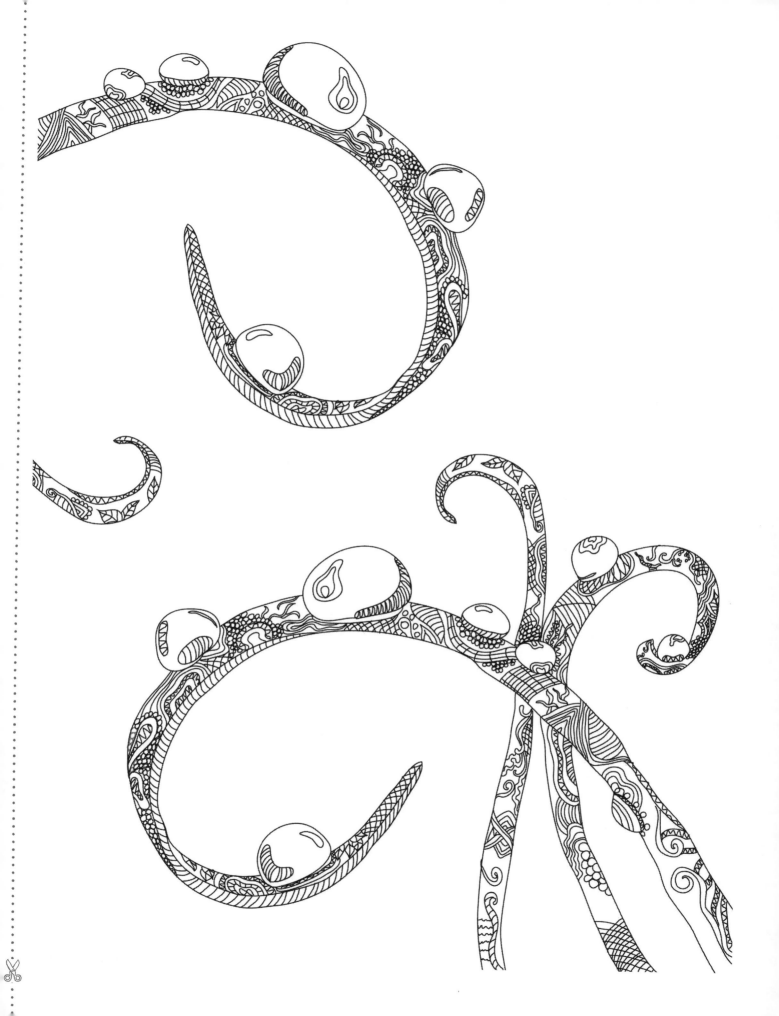

Each place is the right place. The place where I now am can be a sacred space.

Ravi Ravindra

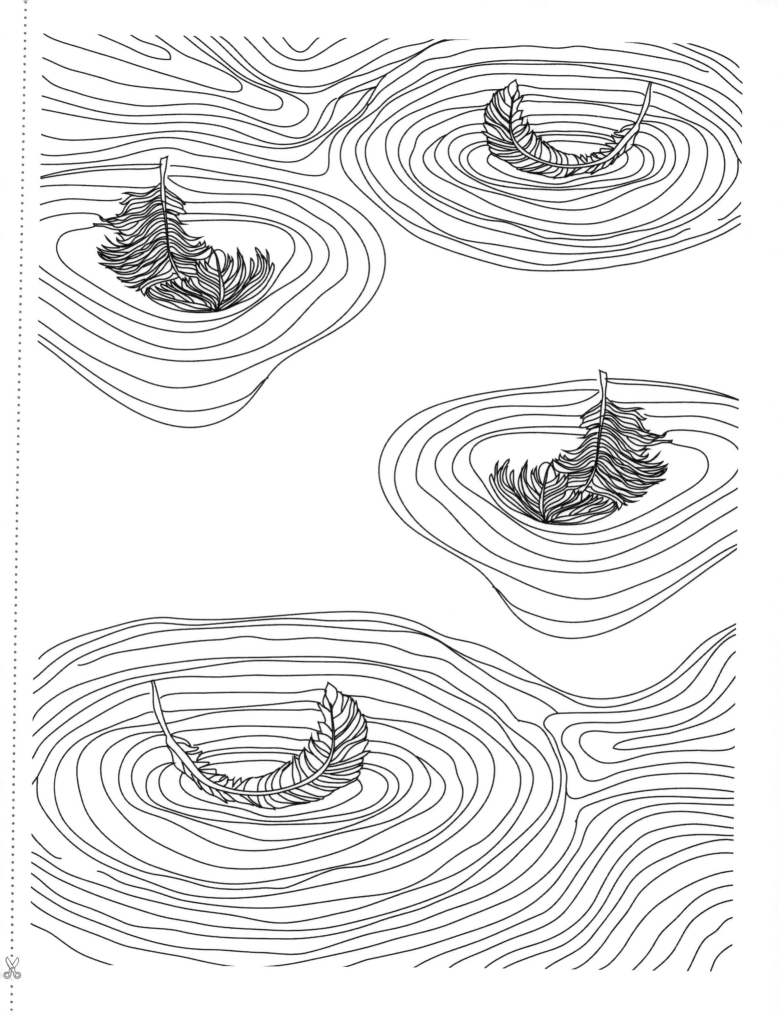

It's good to have an end in mind but in the end what counts is how you travel.

Orna Ross

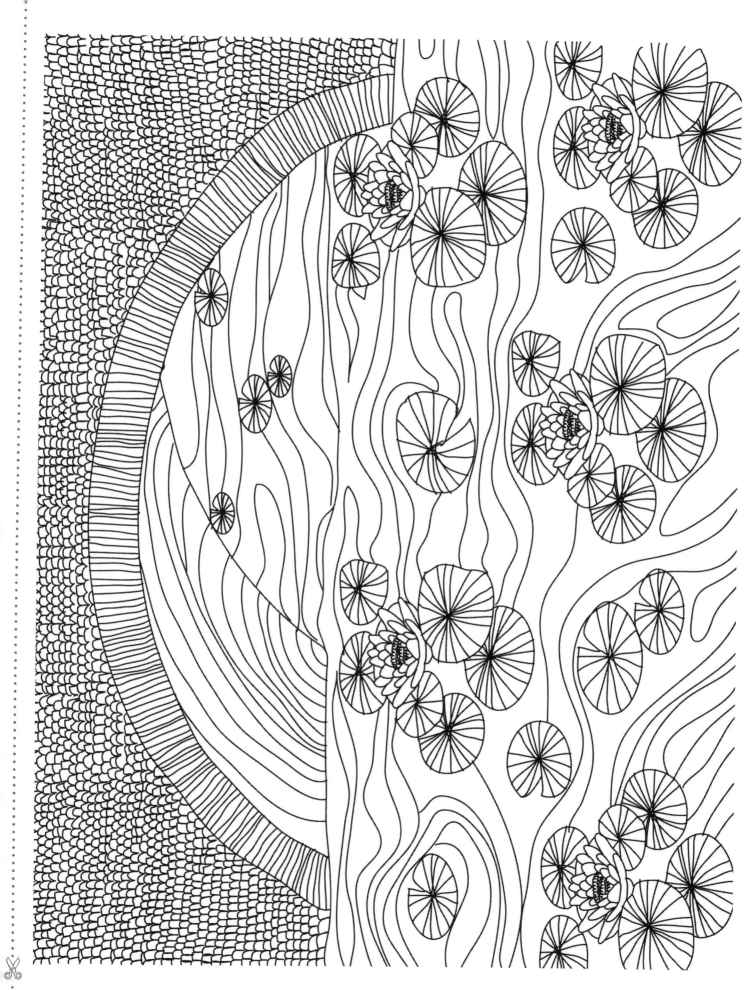

Walk as if you are kissing the Earth with your feet.

Thích Nhất Hạnh

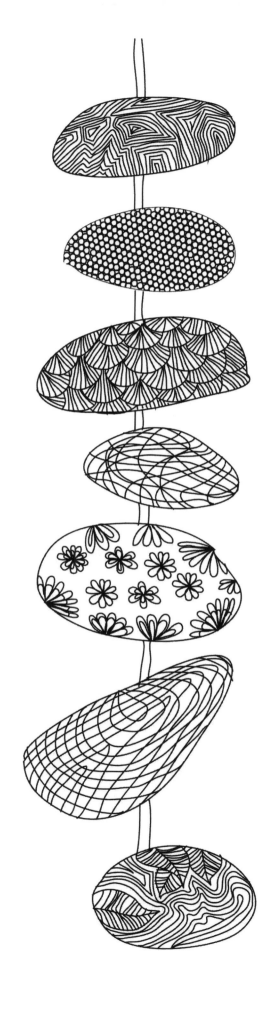

Most of us take for granted that time flies, meaning that it passes too quickly. But in the mindful state, time doesn't really pass at all. There is only a single instant of time that keeps renewing itself over and over with infinite variety.

Deepak Chopra

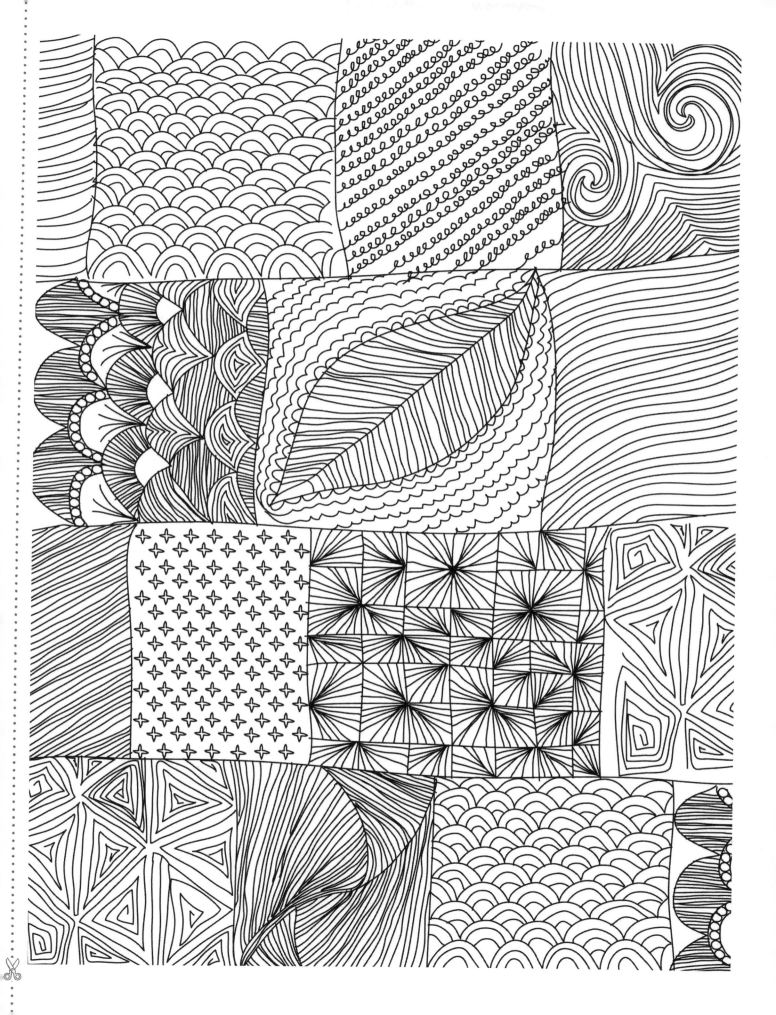

Start living right here, in each present moment. When we stop dwelling on the past or worrying about the future, we're open to rich sources of information we've been missing out on.

Mark Williams

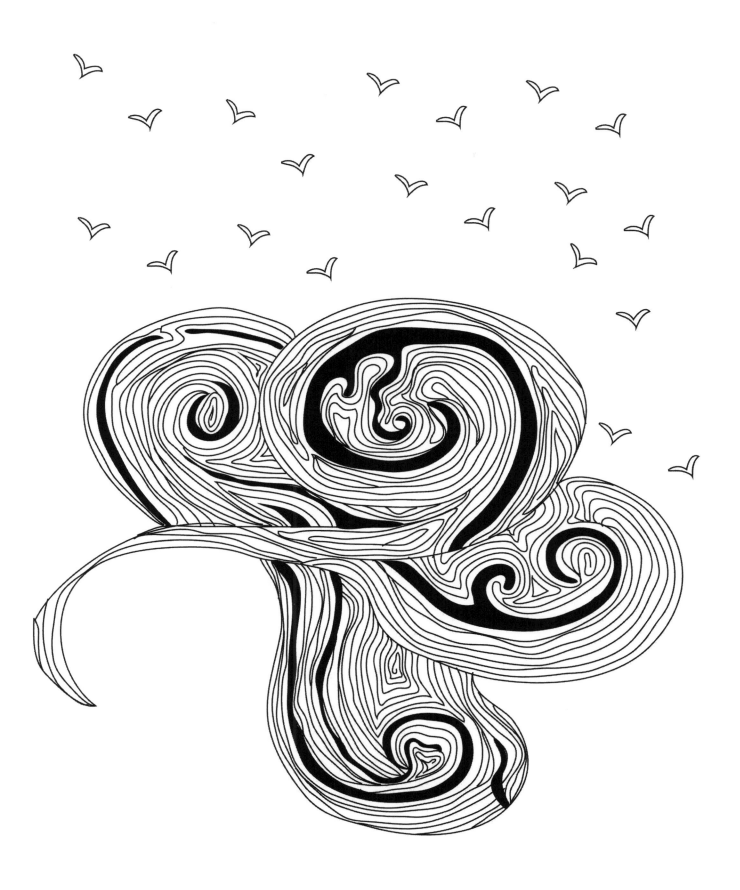

You cannot control the results, only your actions.

Allan Lokos

A mind set in its ways is wasted. Don't do it.

Eric Schmidt

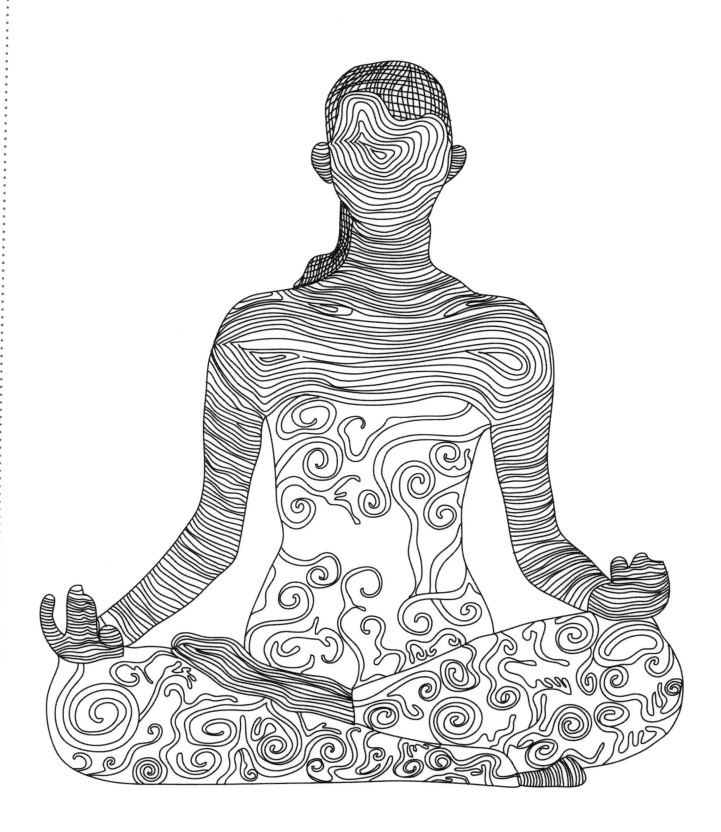

When you reach a calm and quiet meditative state, that is when you can hear the sound of silence.

Stephen Richards

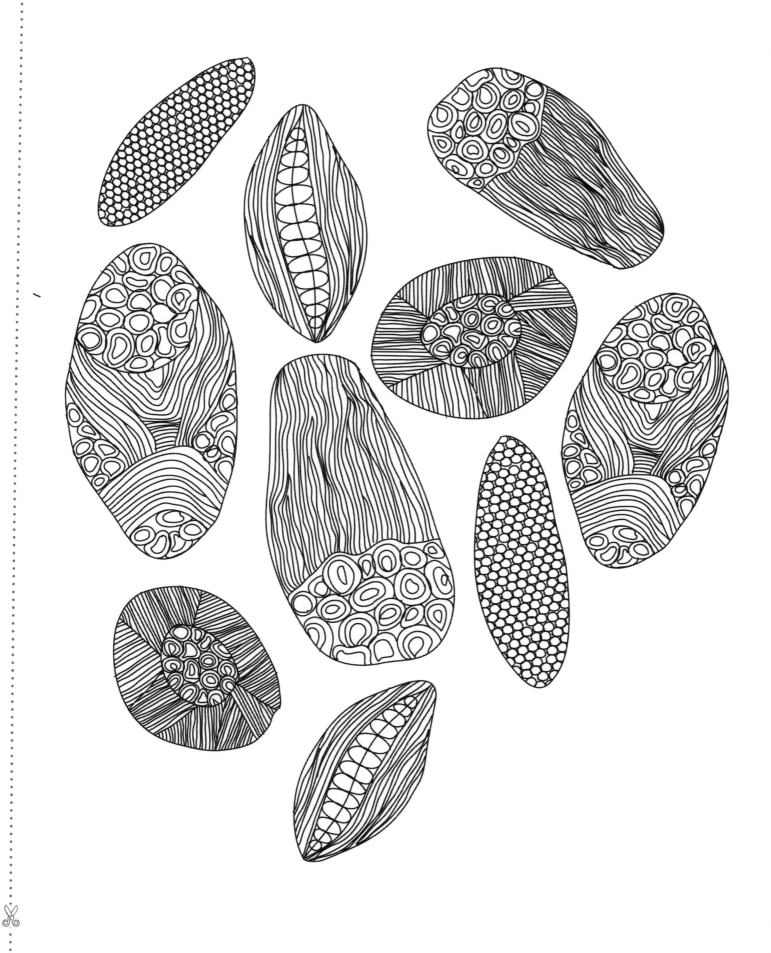

Mindfulness has never met a cognition it didn't like.

Daniel J. Siegel

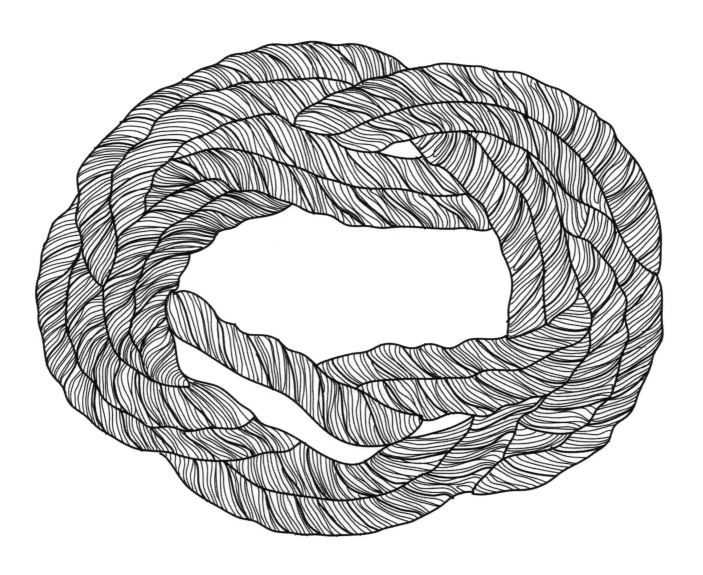

Like a child standing in a beautiful park with his eyes shut tight, there's no need to imagine trees, flowers, deer, birds, and sky; we merely need to open our eyes and realize what is already here, who we already are.

Bo Lozoff

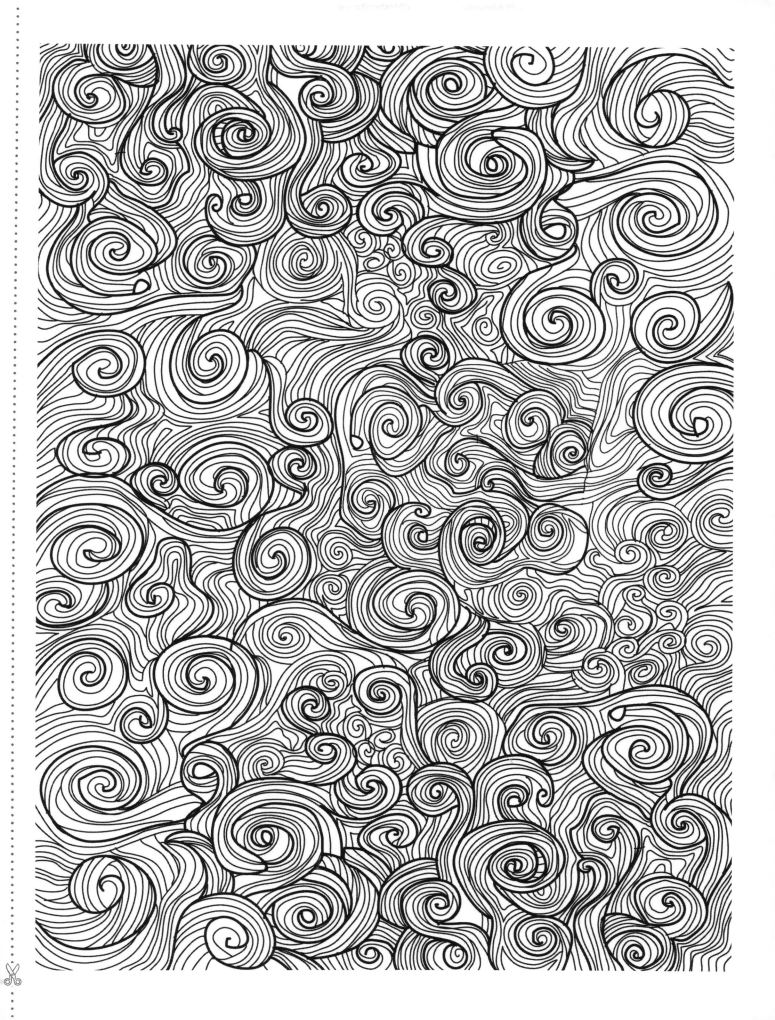

If you really want to remove a cloud from your life, you do not make a big production of it, you just relax and remove it from your thinking. That's all there is to it.

Richard Bach

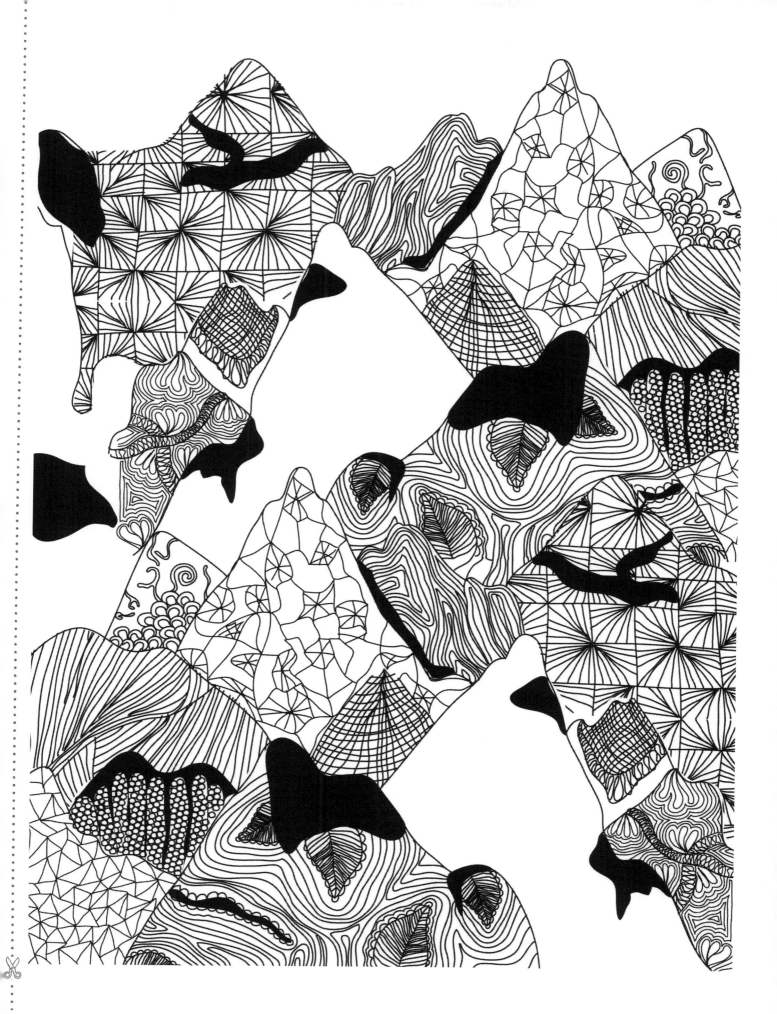

Stop, breathe, look around and embrace the miracle of each day, the miracle of life.

Jeffrey A. White

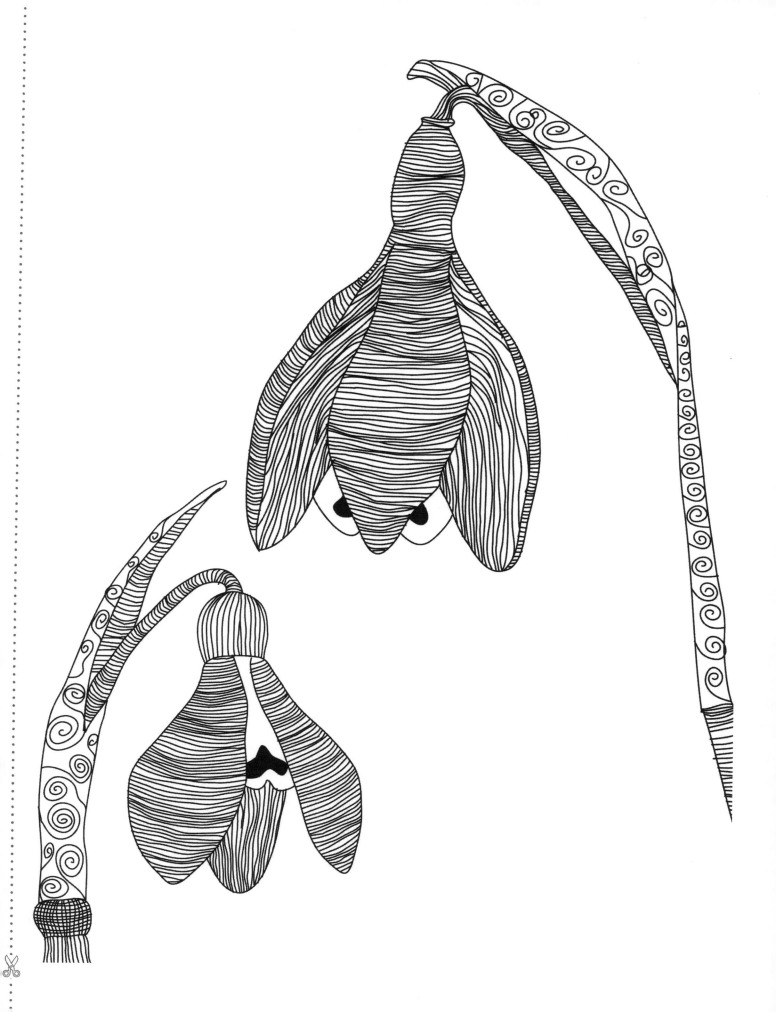

We too should make ourselves empty, that the great soul of the universe may fill us with its breath.

Laurence Binyon

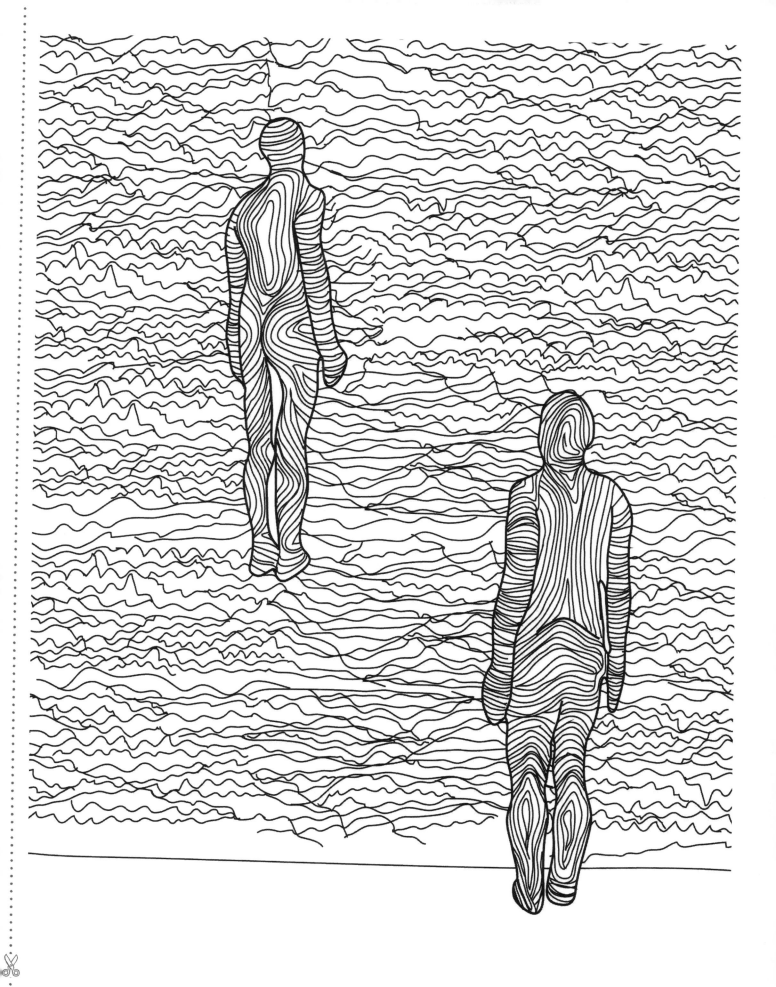

A bird cried jubilation. In that moment they lived long. All minor motions were stilled. Beneath them the earth turned. And only the great ones were perceived, singing.

Sheri S. Tepper

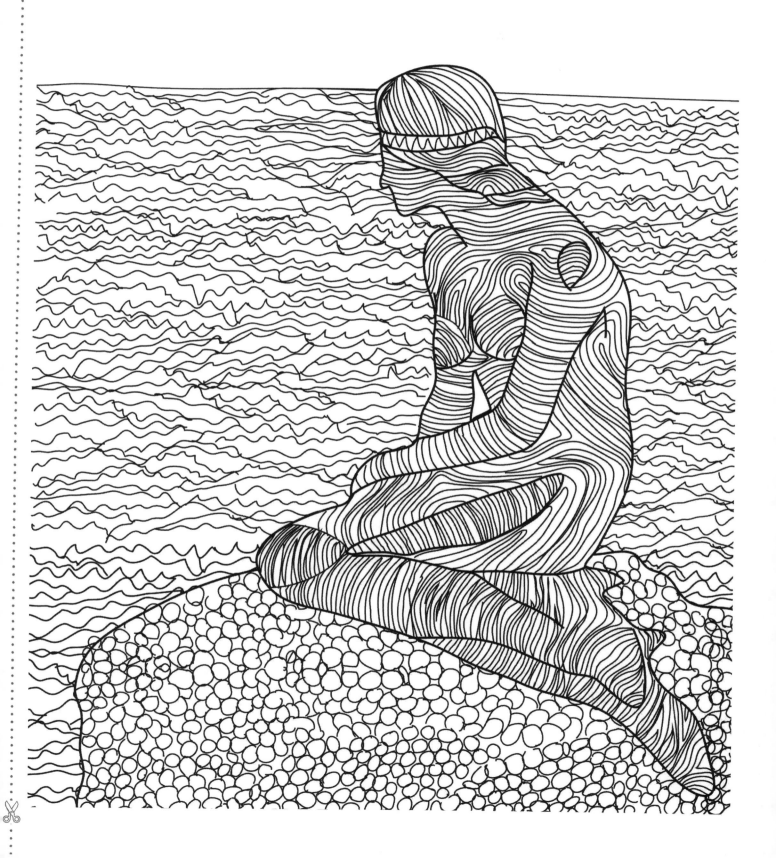

This is what it means to be mindful. To watch the thoughts as they come and go without judgment while completely accepting what arises in the present moment.

Chris Matakas

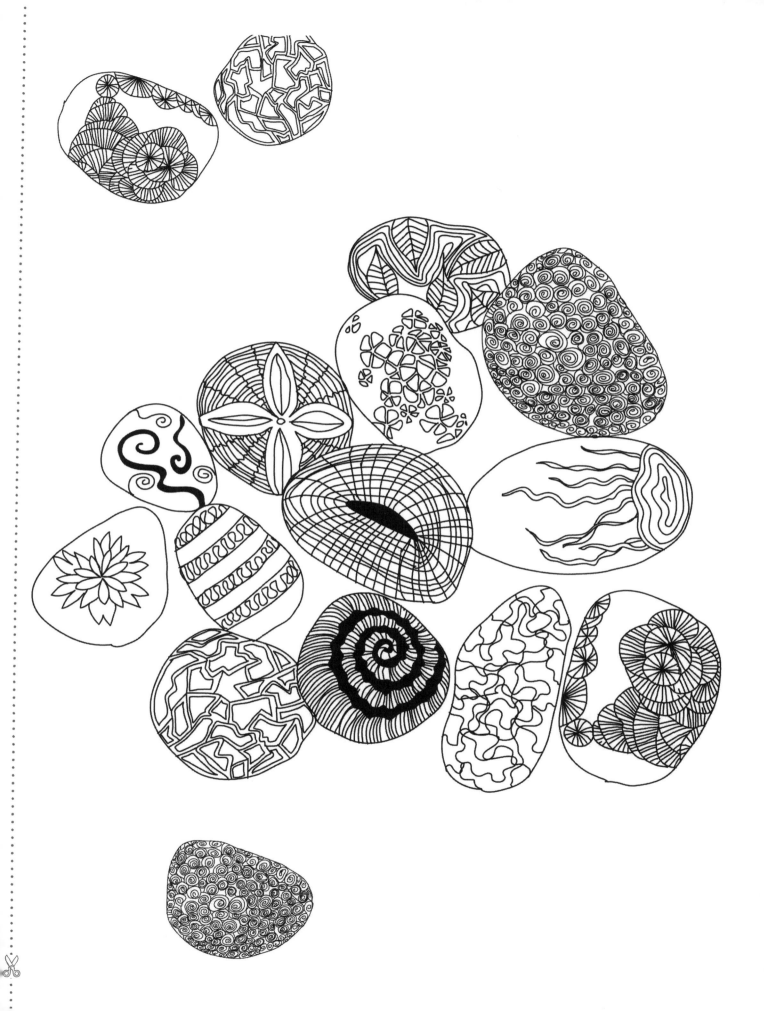

Also by Christina Rose

Printed in Germany
by Amazon Distribution
GmbH, Leipzig